VAN GOGH

LIFE AND WORKS

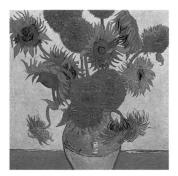

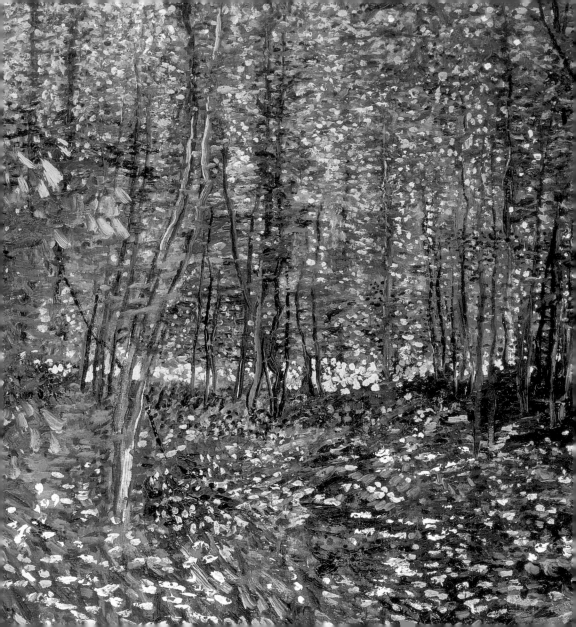

VAN GOGH

LIFE AND WORKS

LINDA WHITELEY

CASSELL&CO

First published in the United Kingdom in 2000 by Cassell & Co
Text copyright © Linda Whiteley 2000
Cover design and layout copyright © Cassell & Co, 2000
Series Editor: Ljiljana Ortolja-Baird
Editor: Andrew Brown
Designer: Bet Ayer

A CIP catalogue record for this book is available
from the British Library

ISBN: 0 304 35566 6

Printed and bound in Italy

Cassell & Co
Wellington House
125 Strand
London WC2R 0BB

Front cover: Self-portrait, 1889 (detail)
Back cover: Noonday
Title page: Woods and Undergrowth (detail)

All illustrations reproduced courtesy of the
Bridgeman Art Library, London

Contents

Introduction

A mong nineteenth-century artists, there can scarcely be a more romantic figure than Vincent van Gogh (1853–90). His brief life, darkened by nervous instability, was marked by a priestlike dedication to his work. His highly personal, brilliant, and graphic style may lack the virtuosity of the work of many late-nineteenth-century draughtsmen, but its power is universally acknowledged. The well-known (and often romanticized) facts of his short, sad existence have at times allowed his work to be perceived as a spontaneous expression of feeling, and as the desperate output of one who knows that there is no time to be lost. The nature of van Gogh's nervous illness has never been satisfactorily diagnosed, but scholars appear to agree that it had little visible effect upon his work, except perhaps for a brief period at Saint-Rémy in 1890. This conclusion is borne out by the surviving letters that van Gogh wrote, chiefly to his brother Theo, upon whom he relied for moral and financial support. They contain many passages of extraordinary lucidity, beauty, and intelligence. Almost all of them bear directly on matters of art. Through these letters we learn of the influences – painterly, literary and moral – that formed van Gogh's mind, and hence his artistic language. For, though his art was not spontaneous, but, rather, the result of constant exertion and, as van Gogh put it, 'a calm ardour for work', it was, to an unusual extent,

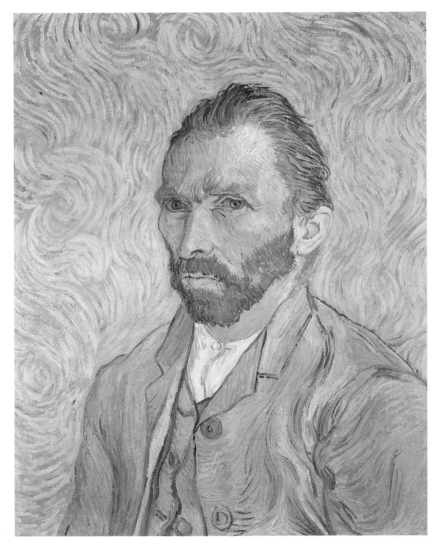

Self-portrait, 1889

expressive of his mind, his reading, and his temperament. He wished his paintings to carry meaning, after the manner of the earlier nineteenth-century French painters Jean-François Millet (1814–75) and Eugène Delacroix (1798–1863), but also to correspond to the reality of nineteenth-century existence as he found it in the contemporary French novel.

For all his love of books, however, van Gogh was never an illustrator of narrative. His art was to be suggestive, but it was to remain pure painting. His ambition carried him beyond Impressionism, into an art that has a suggestive power, akin to the work of the Symbolists, although he rejected Symbolism itself as being too overtly literary. Portraiture gave him a solution to the problem of making an art of spiritual content without narrative. As to its appearance, he wrote, 'the painter of the future will be a colourist such as has never yet existed'. Always conscious of a certain roughness in his art, there were times when he felt that it served him well, and others when he seemed to regret not being able to paint more 'prettily'. Van Gogh came to pin his hopes for modern art on the idea of a community of painters: 'the pictures which must be made so that painting should be wholly itself and should raise itself to a height equivalent to the severe summits which the Greek sculptors, the German musicians, the writers of the French novel reach, are far beyond the powers of an isolated individual'. Van Gogh's letters complete a world only partially realized in his art.

The early years

Van Gogh was born in 1853 in Brabant, near the Dutch border with Belgium. His father was a minister of the Dutch Reformed Church – as were several of his forebears; his mother, the daughter of a bookseller and bookbinder. Two of his uncles were picture dealers. Van Gogh's early attempts to find a career embraced each of these professions: he was in turn a picture dealer, a book dealer, and a trainee candidate for the Church. When, finally, he

chose to become a painter, his love of books and a religious sense of vocation made him a peculiarly imaginative one.

In 1869, at the age of 16, he began to work for Goupil and Co, an international firm of picture dealers that had a branch at The Hague and business connections with the van Gogh family. The firm specialized in contemporary French art and in selling photographic reproductions of popular Salon favourites. This work provided van Gogh with an immense imaginary museum, which was to be a source of inspiration and consolation for the rest of his life. In 1873 he was transferred to the firm's London branch. It would be difficult to exaggerate the impact of London upon him. He 'saw' England through the works of the great nineteenth-century novelists, particularly George Eliot and Charles Dickens. Their expressive powers and humanitarian concerns moved him profoundly. He found a pictorial parallel to Dickens's work in the contemporary black-and-white illustrations that he saw in magazines such as the Graphic and the Illustrated London News. For van Gogh, there was no difficulty in seeing literature in terms of painting, and vice versa. A little later, he was to write to Theo, 'There is something of Rembrandt in Shakespeare, and of Correggio in Michelet, and of Delacroix in Victor Hugo.' Although he did not paint like a Pre-Raphaelite, he admired the poetic intensity of their work, and throughout his life he quoted certain lines by the poet Christina Rossetti.

In May 1875 he was transferred to Goupil's main branch in Paris, but in January 1876, he was discharged, a result of mutual dissatisfaction. Before he left Paris, one event was to leave an indelible impression: the exhibition prior to the sale of a celebrated collection of drawings and pastels by Millet. 'When I entered the hall of the Hôtel Drouot, where they were exhibited, I felt like saying, "Take off your shoes, for the place where you are standing is holy ground".' After a brief return to London, where he worked as an unpaid school assistant, and

a short period working back in Holland, in a bookshop at Dordrecht, in May 1877 he went to Amsterdam to study for a career in the Church. Without completing his degree, he began to work as a lay preacher in the Borinage, a mining district in southern Belgium. Once again, it would seem, his reading coloured his experience: the miners and weavers whose lives he observed in Belgium and in the north of France recalled George Eliot's descriptions in *Felix Holt* and *Silas Marner*, and were to remain for van Gogh essential types of human existence, the subjects of some of his earliest works of art (*see pages 28 and 34*).

In 1880 he decided on a new career, that of a graphic artist, and after receiving some drawing instruction at the Académie Royale des Beaux-Arts in Brussels, followed by several months at home with his parents in Brabant, he moved back to The Hague, where a number of artists were painting rural subjects of a kind associated with Millet. An enthusiasm for modern French culture in The Hague at this time led van Gogh to read the works of the French novelist Émile Zola, who impressed him immensely. Some of his drawings from this period reflect Zola's interests in contemporary urban subjects, and others recall the English illustrators he continued to admire (*see pages 18 and 27*). While at The Hague, van Gogh entered into the only domestic relationship of his life, living with Clasina Hoornik – his model and a sometime prostitute – Clasina's young daughter, and, eventually, her second child. Characteristically, van Gogh seems to have experienced this episode as a literary one – perhaps George Eliot's short story 'Janet's Repentance' was one source; Michelet's *La Femme* was certainly another – but this made him more, rather than less, profoundly affected by the experience, as at least two of his drawings show (*see pages 20 and 24*). For various complicated reasons, among which family influences were strong, he once again left the city for the country, this time for Drenthe, a desolate and remote province in north-east Holland. The landscape there reminded him constantly of the works of seventeenth-century

Dutch artists, as well as those of earlier nineteenth-century French landscape painters such as Georges Michel (1763–1843), Jules Dupré (1811–89), Théodore Rousseau (1817–67), and Jean-Baptiste-Camille Corot (1796–1875). Though there is little surviving work from this short period, it had the effect of enlarging van Gogh's pictorial imagination. 'It is necessary', he wrote to Theo, 'to thoroughly feel the link between nature and pictures in general. I have had to renew that in myself.' He now began to paint in oils, and continued to do so after returning to his father's parsonage at Nuenen. There, he committed himself to the role of peasant painter and started to produce works that he hoped might be suitable for public exhibition. Up to this point, he had taught himself by copying prints and studying drawing manuals, but in 1885, realizing the need for a more professional training, he moved to Antwerp, where for several months he studied plaster casts and the live model in the company of aspiring academic artists; he also began to collect Japanese prints. In February 1886 he felt ready to move to Paris, where Theo was now also working for Goupil and Co.

Paris

Van Gogh arrived in Paris in the year of the last group exhibition of the Impressionists. Through Theo, he came to know several of them. There was by now a younger generation of followers, with whom van Gogh was to be more closely associated: at the studio of Fernand Cormon (1845–1924), where he enrolled, he met Henri de Toulouse-Lautrec (1864–1901) and Émile Bernard (1864–1941), with whom he later worked; he also admired Georges Seurat (1859–91), and felt particularly sympathetic to Paul Signac (1863–1935). His first works were views of Montmartre – half rural, half urban – and still-life paintings of flowers. The appearance of his work had much in common with that of the Paris avant-garde; his literary tastes drew him to the same kind of bleak urban subject matter. Writing from Paris to his sister, he emphasized his continuing interest in the work of modern French

novelists: 'One can hardly be said to belong to one's time if one has paid no attention to it.' A warm interest in Japanese woodcuts was a further point of sympathy with contemporary artists and writers. Van Gogh painted copies of several Japanese prints, one of which appears in the picture that was to be his homage to the cult, the portrait of Père Tanguy (*see pages 60–3*). Once again, images seemed to hold out the possibility of a world to be discovered, and he left Paris for the south of France in February 1888, feeling that he was, in a certain sense, approaching the land of the Japanese print. A little unexpectedly, perhaps, he had written to his sister some months earlier of 'the need of a thoroughly good laugh', after so many years in which 'a desire to laugh was grievously wanting'. Van Gogh's enjoyment of the work of the Provençal writer Alphonse Daudet may have been a reason for his choosing to settle in Arles, a lively historic town in Provence.

Arles and Saint-Rémy

Van Gogh later described his journey south to Gauguin: 'I kept looking out of the window to see if it was beginning to look like Japan.' He had kept his old wish to be a peasant painter: the subjects of his stay – orchards, harvests, cottages, fishing boats, the figure of the sower, portrait 'types' – all recall his former themes, transfigured by the strong colour that he was shortly to employ (a conscious departure from Impressionist practice). He made numerous pen drawings of landscapes that recalled to him the works of Dutch seventeenth-century landscape painters, or rather, in which *he* recalled these same works, for the assimilation was deliberate. One of his hopes in the south was to found his longed-for community of artists; Gauguin was to be its first member. To this end, van Gogh embarked on a series of decorations for his house, the Yellow House, in which sunflowers and gardens were the chief elements. Meanwhile, in the family of Joseph Roulin, an employee of the local post office, he found models for a series of portraits. In Gauguin's company, van Gogh's work began to

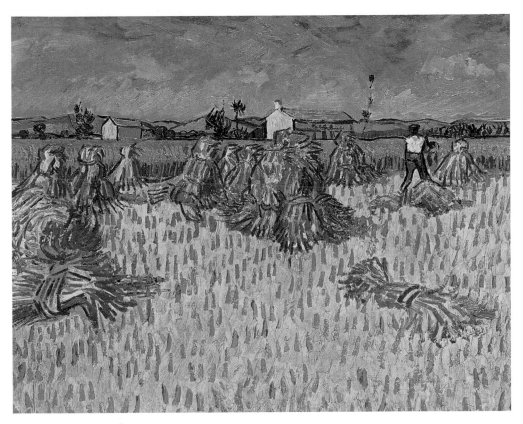

Wheatfields with Sheaves, 1888

show some of the characteristics of Japanese prints – flattened forms and a high viewpoint, noticeable in *Memories of the Garden at Etten* (*see page 103*). His well-known quarrel with Gauguin was followed by a serious nervous attack; while in hospital at Arles, and then in the asylum at Saint-Rémy, he worked on garden subjects, reread old favourite books (including Dickens's *Christmas Stories*, and *Uncle Tom's Cabin*) and painted some of his most memorable and, paradoxically, his most original works, the painted copies after Rembrandt, Delacroix, and Millet, a practice that he described, by a musical analogy, as being comparable to the role of a performer who interprets the work of a composer. Early in 1890, his doctor pronounced him cured. In January of that year the first issue of the journal *Le Mercure de France* carried a long article devoted to him, praising him in elaborate and colourful language, for which he wrote a polite, pleased, but deprecating letter of thanks.

The return to the north

Van Gogh spent the last months of his life at Auvers-sur-Oise, a small town north of Paris, in the care of Paul Gachet, a doctor, a lover of art, and a friend of Paul Cézanne's (1839–1906) and Camille Pissarro's (1830–1903), whose paintings he collected. A feeling of homecoming is expressed in the series of thatched cottages that van Gogh painted in his first weeks at Auvers, followed by the church, and the wheatfields. Soon after arriving, he wrote to Theo, 'I already feel that it did me good to go South, the better to see the North', confirmation of his consistent practice of bringing memory and experience to bear on his painting from nature. Although the letters from this period contain passages of great desolation – the pictorial equivalent of which are probably his wheatfields under troubled skies (*see pages 140–1*) – they also contain some evidence that he was beginning to feel, at last, that his work, particularly in portraiture, was acquiring the capacity to affect the spectator with the strength and simplicity that he so admired in other contemporary artists and writers.

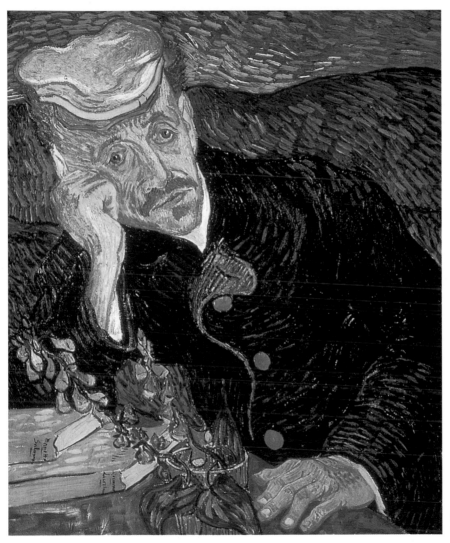

Dr Cachet,
1890

The Early Years

PAINTINGS BETWEEN 1882 AND 1885

Bakery in de Geest March 1882

20.5 x 33.5 cm

Pencil and ink on paper

Gemeentemuseum, The Hague

On his arrival at The Hague, van Gogh made contact with one
of the leading members of the Hague school, Anton Mauve,
a cousin by marriage. However, most of his work from that period
is not in the rural vein associated with Mauve and his colleagues,
but is of a distinctly urban cast, almost certainly stimulated by his
reading of Émile Zola, and his interest in English illustrators,
whose work he was beginning to collect. This is one of a number
of small street scenes that van Gogh made in response to a
commission from his uncle; some of the other drawings include
views of factories or gas-works. The composition may appear
unstudied, but in fact a large preparatory drawing survives for the
figure of the woman on the left.

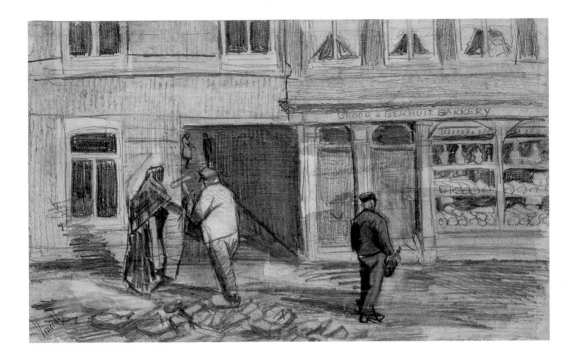

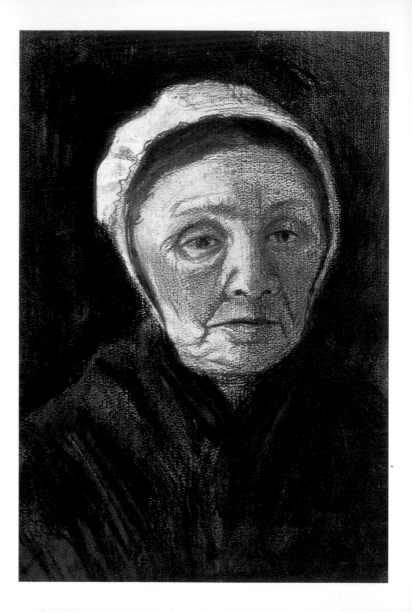

Woman with White Bonnet (Sien's mother) March 1882

36 x 26 cm

Black and coloured chalk and pencil on paper

Gemeentemuseum, The Hague

Van Gogh's ambition was to be a figure painter, but finding
models was difficult. However, in March 1882 he wrote to Theo to
tell him of a new model, 'or rather ... three people from the same
house, a woman ... who looks just like a figure by Édouard Frère,
and also her daughter and a younger child. They are poor people,
and I must say their willingness is boundless.' This drawing is
thought to represent the mother of the woman with whom van
Gogh was soon to be living, Clasina Hoornik (Sien). Since her
appearance reminded van Gogh of Frère, an artist whose work
was similar to that of the Hague school, he may have asked her
to wear the picturesque Scheveningen fisherwoman's cap. The
study is perhaps also an exercise in the style of the series from
the English magazine the *Graphic*, 'The Heads of the People',
which he admired so much. The warm reddish-brown tones of the
chalk are among the first stirrings of colour in van Gogh's work.

Sorrow April 1882

44.5 x 27 cm

Pencil, pen, and ink on paper

Walsall Museum and Art Gallery, Walsall

The starting point for this drawing was a woodcut by Millet: 'Last summer, when you showed me … "The Shepherdess",' he wrote to his brother, 'I thought, "how much can be done with a single contour". But I tried to put some sentiment into this figure. I hope this drawing will please you.' Sien, now pregnant and living with van Gogh, was the model. Her unhappy situation no doubt encouraged van Gogh to include the lines from Michelet's *La Femme*, 'How can it be that a woman is left alone, anywhere on earth', and to write, of a second version, which he later sent to Theo, together with a study of tree roots: 'I wanted to express the struggle for life in both that white, slender figure of the woman, and those angry, gnarled black roots.' The reference to symbolic intention is unusual, and so is the boldly linear style. Perhaps there was a connection between the two. A clue may be found in the choice of an English title, and in his comments to his brother: 'It is obvious that I do not always draw like this. But I very much like the English drawings that have been done in this style, and thus it is not very surprising that I have given it a try myself.'

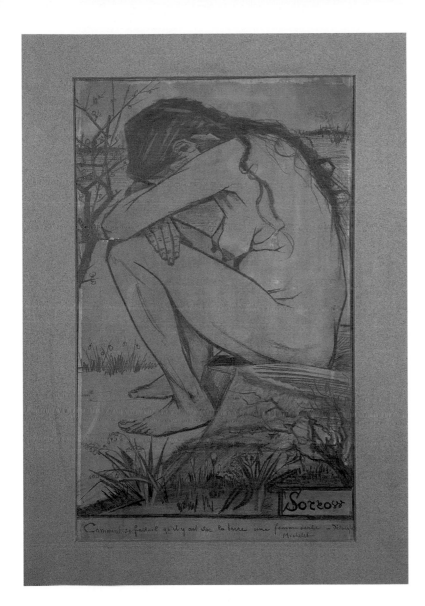

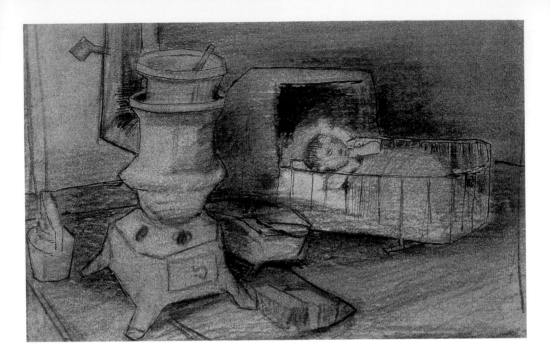

The Cradle

Sketch sent with Letter 218, 21 July 1882
Rijksmuseum Vincent van Gogh, Amsterdam

The intensity of this touching drawing can be understood in the
light of van Gogh's description of the room arranged for his
adopted family: 'A wicker easy chair for the woman in the corner,
near the window … And beside it, a small iron cradle with a
green cover … And though it was only a hospital where she was
lying and where I sat beside her, it is always the eternal poetry of
the Christmas night with a baby in the stable as the old Dutch
painters saw it,… a light in the darkness, a star in the dark night.
So I hung the great etching by Rembrandt over it, the two women
by the cradle, one of whom is reading from the Bible by the light
of a candle, while great shadows cast a deep chiaroscuro over
the room.'

The State Lottery Office, The Hague September 1882

38 x 57 cm

Watercolour and gouache on paper

Rijksmuseum Vincent van Gogh, Amsterdam

Throughout his stay in The Hague, van Gogh took models from typical figures or groups in the street. Of this composition, he wrote: 'The little group of people – and their expression of waiting … assumed a greater and deeper significance for me than in the first moment.' A few months earlier, Luke Fildes's *Houseless and Hungry* appeared in a list of engravings mentioned by van Gogh; in this print, and in M. Fitzgerald's *Pawn Office at Merthyr Tydfil*, also known to van Gogh, groups of poor people wait in similar manner at a door hoping for relief. Unlike the English artists, however, van Gogh does not emphasize the pathos, but leaves it to the imagination.

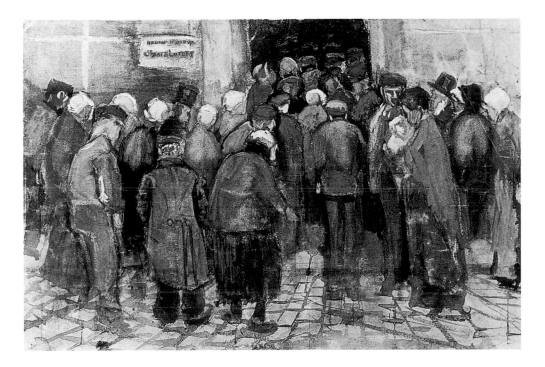

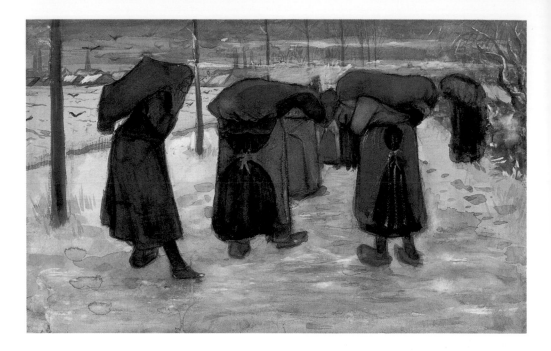

Women Miners November 1882

32 x 50 cm

Watercolour, heightened with white, on paper

Rijksmuseum Kröller-Müller, Otterlo

Based on a drawing that van Gogh had made three years earlier,
in the mining region of the Borinage in Belgium, this watercolour
shows a greatly improved mastery of form – though not without
considerable trouble, since he had to make twelve preparatory
figure studies. One of them came right only when the action of
carrying was demonstrated to him by a station porter. We should
know, even if he had not told us, that: 'Its realism is something
like the *Gleaners* by Millet.' Revealingly, he explained that he had
not wanted to make a snow effect of it, for then it would seem as
if it were done for the sake of the landscape; for him, the figure
was always to be the more significant element.

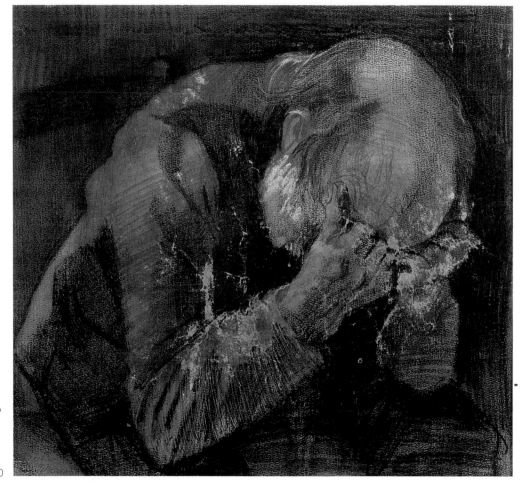

Old Man with Head in Hands November 1882
45.5 x 47.5 cm
Black lithographic chalk, pencil, and wash,
heightened with white, on paper
Rijksmuseum Kröller-Müller, Otterlo

The figure is one of the 'orphan men', as they were known,
inhabitants of the Old People's Home, whom van Gogh, eager
for models, often drew. It is a version of a similar drawing, in
reverse direction, that van Gogh made into a lithograph, giving it
the title 'At Eternity's Gate'. The image remained in his mind,
linked with a melancholy poem by Thomas Moore called 'The
Light of Other Days', and it recurs in his work in various forms.
The lithograph was one of a series made towards the end of his
stay in The Hague as part of a scheme to draw 'types of
workmen of the people for the people, distributing them in a
popular edition and taking the whole as a matter of duty and
public service'.

Man pulling a Harrow

Sketch in Letter 336, 28 October 1883
Rijksmuseum Vincent van Gogh, Amsterdam

Van Gogh's retreat from The Hague to the remote province of
Drenthe may have been partly stimulated by his reading, earlier
in the year, of Alfred Sensier's biography of Millet. He found the
landscape 'splendid'; it confirmed his vocation, though he was
not yet able to paint it as he would like. He wrote frequently to
Theo, hoping that he, too, would become a painter, urging the
beauty and even the necessity of the artist's life, not as a
consequence of 'natural gifts', but 'with a certain assurance that
one is doing a reasonable thing, as the farmer drives his plough,
or as our friend in the scratch below, who is harrowing'. The
'scratch' seems to be a partial quotation from one of Millet's
most desolate landscapes, *Winter with Crows*, but the
abandoned harrow of that picture is here expressive of the toil
and self-reliance that must accompany the pursuit of art.

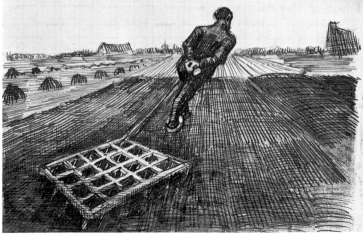

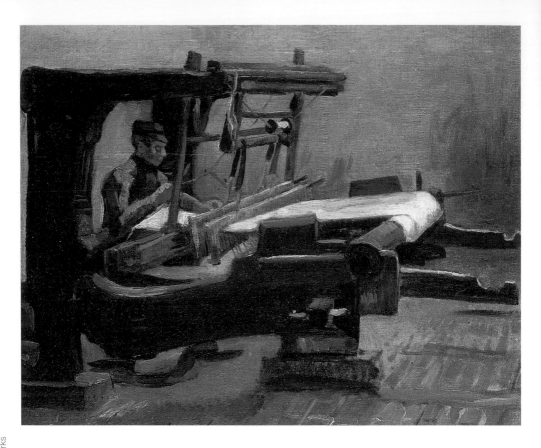

Weaver February 1884

37 x 45 cm

Oil on canvas

Private Collection

At the end of 1883 van Gogh moved back to his parents'
parsonage at Nuenen, where he would spend the next two years.
Rural workers, including weavers, were subjects that absorbed
him for much of this period. He wrote to Theo early in 1884:
'Every day I am busy painting studies of the weavers here, which
I think are technically better than the painted studies done in
Drenthe.' The complicated structure of the looms, and the
difficulties of obtaining a correct perspective in the tiny rooms of
the weavers' cottages were a challenge to his skill, but the
subject had, as usual, other attractions. The weaver, 'with his
dreamy air, almost a somnambulist', recalled George Eliot's
Silas Marner; the Rembrandtesque effects of the rooms in
lamplight made him think of Millet; the scenes required, as he
observed, colours and tones that would place them within a
thoroughly Dutch tradition.

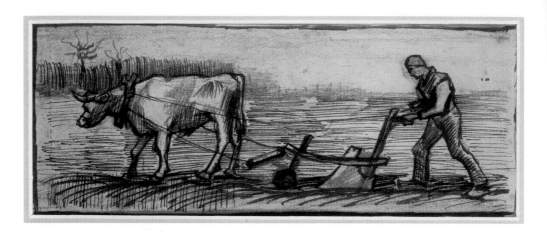

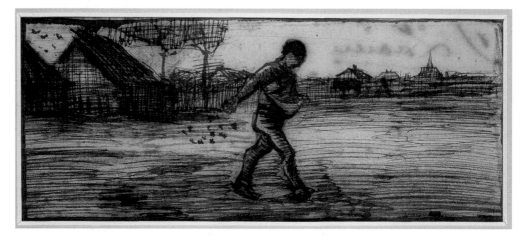

Ploughing August 1884
5.5 x 15 cm
Pen and ink on paper
Private Collection

The Sower August 1884
5.5 x 14 cm
Pen and ink on paper
Private Collection

In August 1884, van Gogh received a commission from goldsmith and amateur artist Anton Hermans. Hermans wished to paint his dining room himself, and asked van Gogh for a set of painted sketches to use as models. Van Gogh does not seem to have objected to this faintly surprising request – the deal included covering all costs, and thus a welcome supply of oils and canvas – but he persuaded Hermans to choose country life as his subject instead of a neo-Gothic version of the Last Supper, as Hermans had intended. 'I told him that – as it was a dining room – the appetites of those sitting at the table there would be considerably more stimulated, in my opinion, if they saw scenes from the rural life of the district on the walls instead.' Van Gogh made six preliminary sketches – 'It's a job I enjoy doing' – of a sower, a ploughman, a wheat harvest, potato planting, a shepherd, and a winter scene with an ox-cart. They are seasonal rural activities and resemble some of the small sketches from Drenthe that van Gogh had included in letters to Theo, one of which shows a ploughman, and another, potato pickers. The scene with the ox-cart shows a row of pollarded willows, a subject of one of

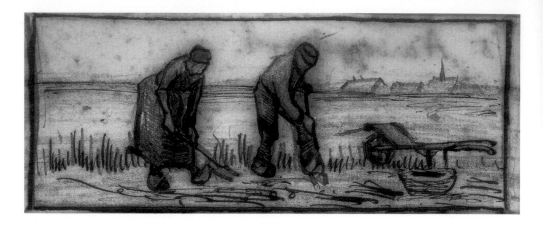

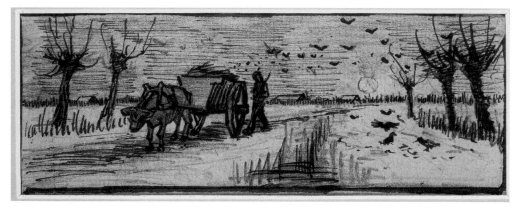

Planting Potatoes
August 1884
5 x 13 cm
Pen and ink on paper
Private Collection

Ox-cart August 1884
5 x 13.5 cm
Pen and ink on paper
Private Collection

his earliest drawings, and a sight that always moved him. Also among the early drawings is a copy after Millet's *Sower*, a figure that was to be a recurring image in van Gogh's work. These scenes are a homage to Millet, executed in a pictorial language resembling his, insofar as they depict, with strict economy of detail, full-size figures silhouetted against a lonely plain. At the same time, they are confirmation of a conviction that van Gogh expressed figuratively in a letter from Drenthe of the previous year (*see page 33*), at a time when Millet and 'the old Dutch artists' were much in his mind: 'in order to grow, one must be rooted in the earth'.

Peasant Woman Gleaning July 1885

51.5 x 41.5 cm

Black chalk on paper

Folkwang Museum, Essen, Germany

The series of studies of figures harvesting, drawn in the summer of 1885, may have been undertaken with the idea of combining them into a large picture in the manner of Millet or Jules Breton (1827–1906). Van Gogh owned a print after Millet's *Gleaners*, a composition that must have been in his mind as he worked. His drawing surpasses Millet in rendering bulkiness of form, but he uses different means from the older artist. His contours are consistently broken, and juxtaposed bands of hatching in different directions do not allow the smooth passages from light to dark that give Millet's drawings their more ideal character.

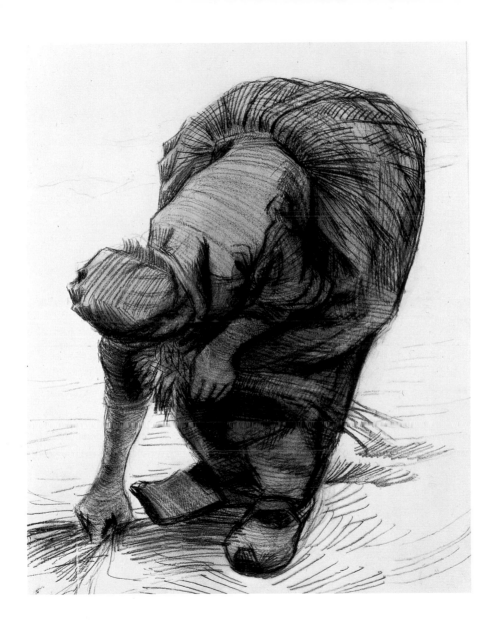

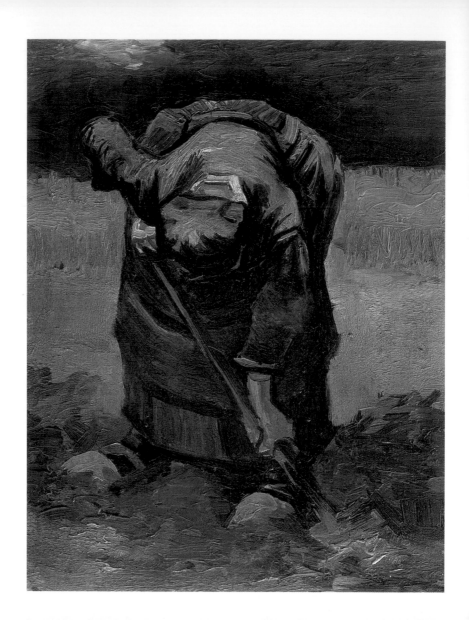

Peasant Woman Digging August 1885

42 x 32 cm

Oil on canvas, laid down on wood

The Barber Institute of Fine Arts, University of Birmingham

These painted studies represent the final stage of van Gogh's development as a painter in a purely rural tradition. However, he was already susceptible to the power of colour, as he had written to Theo earlier in the year: 'I am also looking for blue all the time … The people here … wear the most beautiful blue I have ever seen … When this fades and becomes somewhat discoloured by wind and weather, it is an infinitely quiet, delicate tone that brings out the flesh colours. But this is a question of colour, and what matters most to me at the point I'm at now is the question of form.' This search for mastery of form led to his decision to leave for Antwerp, and to enrol at the academy.

Paris

PAINTINGS BETWEEN 1886 AND 1888

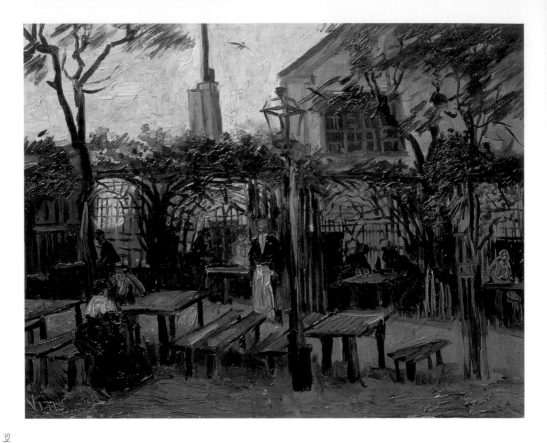

La Guingette, Montmartre Autumn 1886

49 x 64 cm

Oil on canvas

Musée d'Orsay, Paris

After brief studies in Antwerp, van Gogh moved to Paris in 1886. Among his early subjects are panoramic views of the city, seen from Montmartre, where he shared a flat with his brother in the rue Lepic. As was the case in The Hague, his interest in urban subjects was almost certainly stimulated by reading French novels. This scene, a modest suburban cafe, is the kind of subject that Édouard Manet took up in *Chez le Père Lathuile*, but the unfashionable clientèle, caged trees, gaslight, and soaring bird all belong to van Gogh's own vocabulary.

Outskirts of Paris Autumn 1886

46.5 x 54.5 cm

Oil on canvas

Private Collection

The view – a dismal stretch of field, neither town nor country –
shows the area that lay beyond the ramparts at the foot of the
northern slope of the hill of Montmartre. Such bleak landscapes
were to the taste of Paul Signac and Jean-François Raffaëlli
(1850–1924), two artists whom van Gogh admired, but he gives
the scene a certain original character. Its nearness to Paris in the
distance is less obvious, as if the artist might have approached
the scene from the far side. The gaslight, incongruous in such a
waste land, balances the figure of the man in the foreground, as
a tree might in a landscape by Corot; an irony matched by the
couple, faintly idyllic, moving to the right.

Moulin de la Galette Autumn 1886

38 x 46.5 cm

Oil on canvas

Nationalgalerie, Berlin

Nothing in this picture recalls Renoir's cheerful view of dancing couples at the Moulin de la Galette. The windmills of Montmartre may have reminded van Gogh of Holland, but they occur much more frequently in his Paris subjects, sometimes in an urban setting, at other times overlooking the vegetable gardens of Montmartre, still partly rural in character at this time. This picture, like the preceding one, suggests the melancholy, associated with descriptions by Zola and the Goncourt brothers, to which van Gogh was particularly sensitive in Paris. The mood is matched by a palette that is in lighter tone than in the previous year at Nuenen, but greyish in colour.

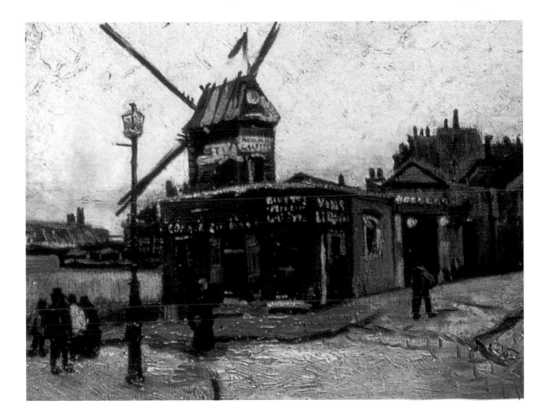

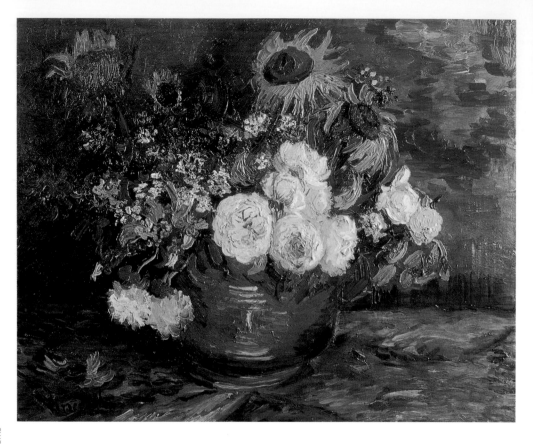

Bowl with Sunflowers, Roses and Other Flowers

Summer/autumn 1886

50 x 61 cm

Oil on canvas

Städtische Kunsthalle, Mannheim

Among the 92 oil paintings that van Gogh is known to have made while in Paris, about 40 are flower pieces, in which, characteristically, he was working on various technical problems: lightening his palette, reaching greater flexibility of brushwork, and developing the use of complementary colours. Henri Fantin-Latour's (1836–1904) still-life subjects come to mind, but the energy and brio of this marvellous arrangement is closer to Fantin's own hero, Delacroix. These appear to be van Gogh's first painted sunflowers; when he came to paint his celebrated series in Arles, he remembered the sunflowers that he had looked at with pleasure in Montmartre.

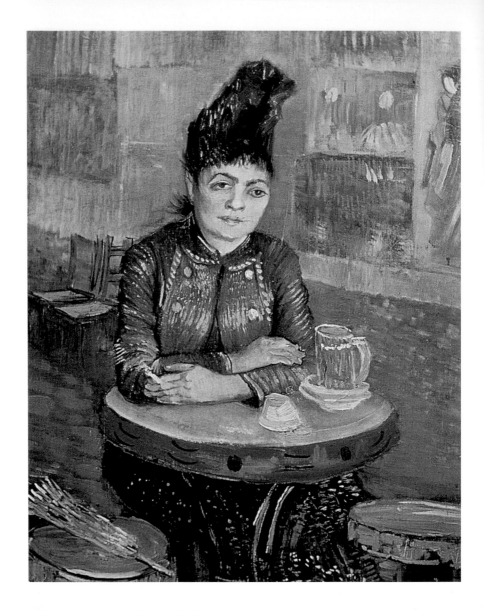

Café Tambourin Winter 1886–1887

55.5 x 46.5 cm

Oil on canvas

Rijksmuseum Vincent van Gogh, Amsterdam

While in Paris, van Gogh worked for a time in Fernand Cormon's
studio, where he met Émile Bernard, Louis Anquetin (1861–1932),
and Toulouse Lautrec. Van Gogh was to be the instigator of
exhibitions including works of this little group at two cafés, one of
which was the Tambourin, whose proprietor, Agostina Segatori,
is the subject of this picture. Here, however, the walls appear to
be hung with Japanese prints, another exhibition arranged by
van Gogh in early 1887. The subject, a solitary woman, with
intent gaze, at a café table, recalls Manet or Degas; the pearly
complexion and dark eyes seem indebted to Renoir; the choppy
strokes in the manner of pastel, the strange outline of the hat,
tambourine-shaped table and stool, and slightly raffish modernity
are closer to the world of Toulouse-Lautrec.

Restaurant de la Sirène, Asnières Summer 1887

51.5 x 64 cm

Oil on canvas

Ashmolean Museum, Oxford

Émile Bernard, van Gogh and Signac regularly went on painting
expeditions to Asnières, a popular suburb on the Seine to the
west of Paris, and the location for Seurat's great bathing picture
in the National Gallery in London. The subjects to be painted
there – bathing, boating, eating in restaurants – were not very
different from those associated with the older generation of
Impressionists, but the setting was less genteel. Van Gogh
painted two views of the restaurant, both from viewpoints
demanding mastery of perspective. Most striking are van Gogh's
use of broken strokes of brilliant colour, the juxtaposition of
complementary colours, and the recurring visibility of the pale
canvas, all of which were an adaptation of the practices of the
Neo-Impressionists. The technique, resembling drawing, is a
characteristic of van Gogh's later work.

Woods and Undergrowth 1887

46 x 55.5 cm

Oil on canvas

Rijksmuseum Vincent van Gogh, Amsterdam

Under the influence of Impressionist painting, van Gogh began to use paler and more brilliant colours, and for a time applied his paint in small broken touches. However, when painting this luminous woodland scene, he may also have been thinking of the older generation of landscape painters, Théodore Rousseau, Corot, and particularly Narcisse-Virgil Diaz de la Peña (1807–76), whose paintings of the dappled effect of light through trees were the epitome of the genre. The feeling for nature of this generation of artists meant that van Gogh found their work in many ways more congenial than that of his French contemporaries. The forms of roots and trees had long interested him; as so often, he was reworking a favourite theme in a new idiom.

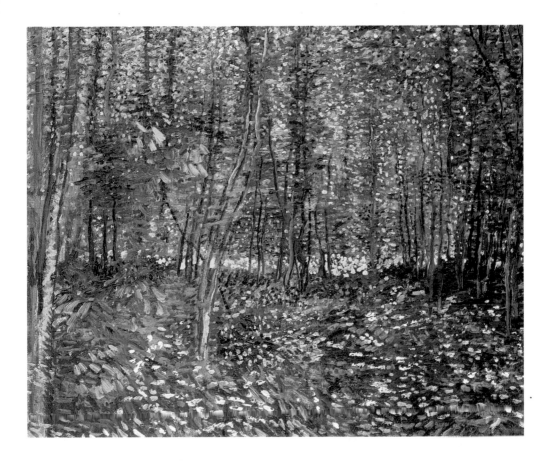

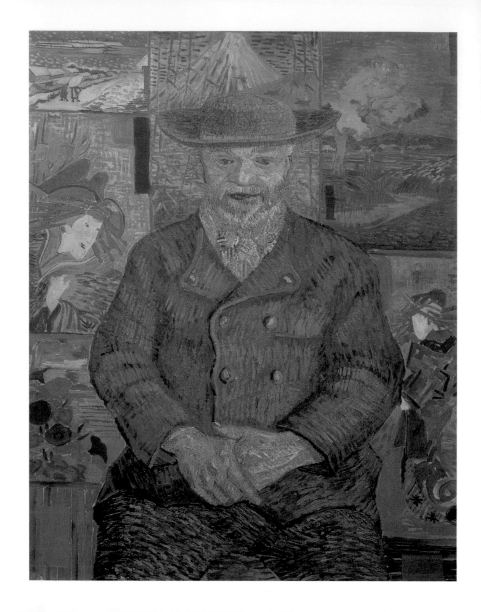

Père Tanguy Winter 1887–8

92 x 75 cm

Oil on canvas

Musée Rodin, Paris

The candour and simplicity of Père Tanguy, a colour merchant
and modest picture dealer, represented for van Gogh something
of his imagined ideal of the Japanese character. He painted
Tanguy twice, each time against a background of carefully
arranged prints. Their function in the portraits is probably
symbolic only, a tribute to the qualities of the sitter. Van Gogh
had collected Japanese prints since his Antwerp days, and
made painted copies of at least three, one of which appears
here, in the elongated figure of a woman to the right. The visible
brushstrokes produce an effect very different from a woodcut,
but in his letters van Gogh makes it clear that it was the
simplicity, clarity, and rapidity of Japanese art that he hoped to
emulate: 'they do a figure in a few sure strokes as if it were as
simple as buttoning your coat'.

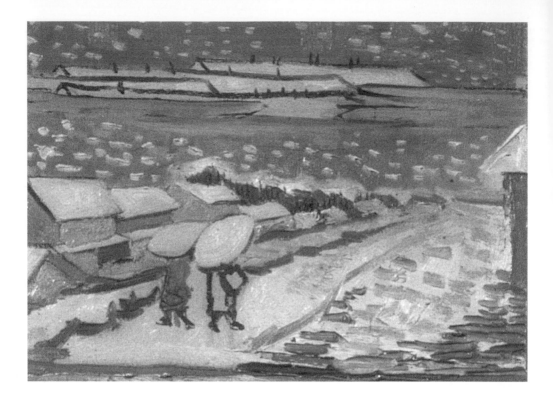

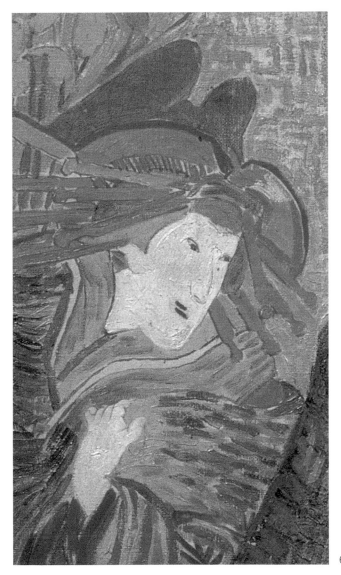

The Journey South

PAINTINGS OF 1888 AND 1889

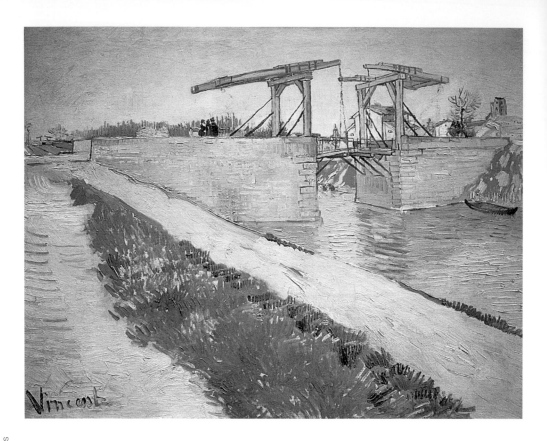

Pont Langlois, Arles March 1888

58.5 x 73 cm

Oil on canvas

Rijksmuseum Vincent van Gogh, Amsterdam

Snow was on the ground when van Gogh arrived in the south of
France. As soon as he was able to work out of doors, he painted
several pictures based on this composition. The drawbridge
seen here, such a familiar sight in Holland, was apparently
constructed by Dutch engineers. However, the simplicity of
treatment, the limited range of pictorial elements, the prominent
foreground, and the structure of the bridge itself give this picture
a faintly Japanese air, as if van Gogh, newly arrived in the south,
wanted to find his new home as much as possible like the land of
his imagination.

Orchard April 1888

55 x 65 cm

Oil on canvas

National Gallery of Scotland, Edinburgh

Flowering trees, like the bridge in the preceding picture, bring
to mind Japan, and perhaps for this reason they caught van
Gogh's imagination at this early stage of his time in Arles. He
was taking up a motif familiar from the work of Charles-François
Daubigny (1817–78) and Pissarro, in a style that still owed much
to Impressionism, though scrutiny of the brushwork reveals some
differences. Van Gogh painted a series of orchards in the spring,
planning to arrange them in triptychs – a central canvas flanked
by two others – characteristic of his habit of viewing certain of
his pictures as modern and secular equivalents of religious
imagery. Unlike the other orchards, this one includes a view of a
factory, which increases its resemblance to the kinds of subject
familiar to him while working at Asnières.

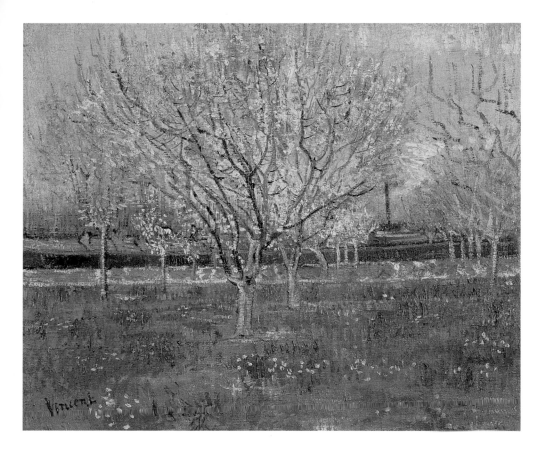

Vincent

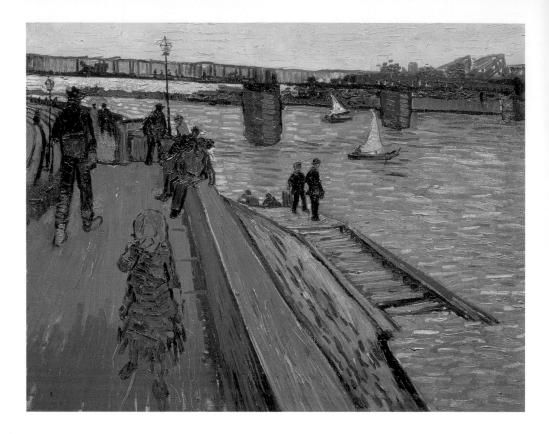

Pont de la Trinquetaille June 1888

65 x 81 cm

Oil on canvas

Private Collection

The iron bridge over the River Rhône linked Arles to the suburb
of Trinquetaille. The urban subject is rare in van Gogh's
Provençal work, and the palette is unusually muted. Modern
and faintly industrial, it could be taken for a view at Asnières. But
the high viewpoint, flattened areas of colour, sharply dwindling
perspective, and pale yet bright tonality are different in character
from the Paris work. The figure of the girl recalls those of
Édouard Vuillard (1868–1940); the structure as a whole seems
to parallel, in lighter mood, the vision of the Norwegian painter
Edvard Munch (1863–1944), underlining the affinities, remarked
on by art historian Robert Rosenblum, between van Gogh and
the Northern tradition of expressive landscape painting.

Boats at Saintes-Maries de la Mer May–June 1888

44 x 53 cm

Oil on canvas

Pushkin State Museum of Fine Arts, Moscow

Van Gogh's brief visit to the Mediterranean had an immediate and dramatic effect upon his work. He wrote, 'Now that I have seen the sea here, I am absolutely convinced of the importance of staying in the Midi and of piling on the colour.' It has been noted that at this point he ceased to employ the perspective frame, a mechanical device that he had used since his early days in The Hague to help him to apply the laws of perspective. He wanted to allow his drawing to become freer, more rapid, 'more exaggerated', as is evident in this seascape with small boats, a subject that he had formerly painted at Scheveningen in The Netherlands, but which is now full of light, colour, gaiety, and movement.

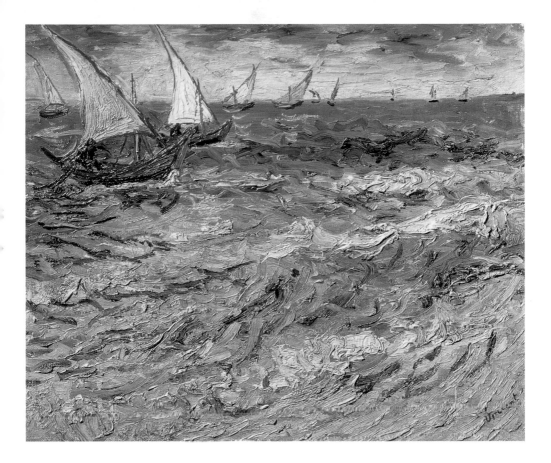

Landscape near Montmajour July 1888

49 x 61 cm

Pencil, reed pen, and brown ink on paper

British Museum, London

The art historian Ronald Pickvance tells us that this view is taken looking north-west from Montmajour towards the Rhône, the range of the Alpilles to the right. (Alphonse Daudet's Tartarin was president of the local climbing club). The little train, with trucks and curiously shaped carriages, ran from Arles to Fontvieille, where two painter friends of van Gogh's lived. The sweeping landscape, taken from a high viewpoint, is often compared with the work of seventeenth-century Dutch artist Philips de Koninck (1619–88), but its frequently crossing diagonals and curving forms give it a very different aspect. The lively notation, reminiscent of print techniques, varies in force from foreground to background, heightening the sense of space and distance. The row of trees, the cart, and figures may be later additions made in the studio.

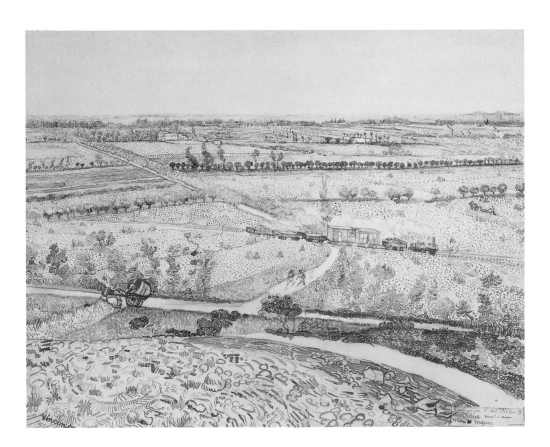

Wheatfields with Sheaves June 1888

50 x 60 cm

Oil on canvas

Israel Museum, Jerusalem

For van Gogh, the harvest was the most beautiful of seasons. In June he began to paint the wheatfields, taking up the theme he had been working towards with his figure studies at Nuenen, but now with emphasis on the sheaves, which held a particular significance for him, as did the theme of the sower, a subject that he was to take up again at about this time, with, as in this picture, powerful intensification of colour, particularly of the 'high yellow note' associated with his first summer in the south. The rapid brushwork, as if taking notes of the scene, may relate to his expressed admiration for the simplicity and rapidity of Japanese technique. The choice of subject, and indeed the silhouette of the man to the right in this painting, remind us that Millet's work was once again in his mind.

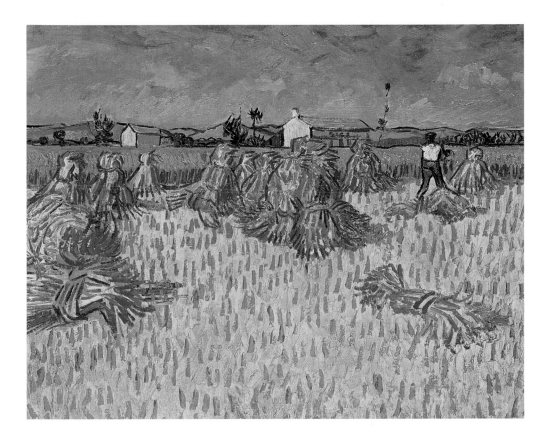

80

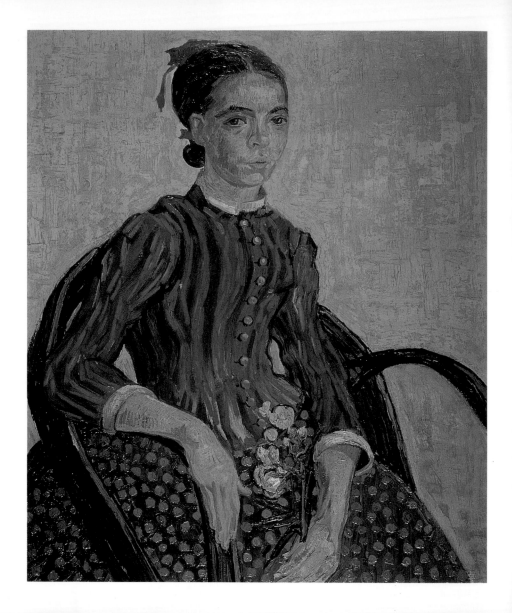

La Mousmé July 1888

74 x 60 cm

Oil on canvas

National Gallery of Art, Washington, DC

Van Gogh wrote to Theo explaining the meaning of the word
mousmé, which he had learned from Pierre Loti's novel *Madame
Chrysanthème*, and which he greatly enjoyed pronouncing to
himself: 'A Japanese girl – Provençal in this case – twelve or
fourteen years old'. Holding a sprig of oleander, she is
gracefully at home in the cane chair from which Roulin seems
to long to spring (*see page 85*). The small oval head, with
delicate ribbon behind, clear contour, elaborate though rustic
costume, and calm demeanour all lend this something of the
air of a portrait by Ingres.

Joseph Roulin August 1888

81 x 65 cm

Oil on canvas

Museum of Fine Arts, Boston, Massachusetts

'A head somewhat like Socrates', van Gogh wrote to his younger sister, '… an ardent republican and socialist, reasons quite well and knows a lot of things.' Van Gogh was to paint Roulin again, and his entire family, later in the year, and he seems to have found comfort in their friendship. However, his remarks to his sister suggest that in this portrait he was also seeking a type, as he generally did; he must have had in mind the 'Heads of the People' series from the *Graphic*, to which he so often referred with admiration, since the figure, seen from a low viewpoint, close to the picture plane, is remarkably like Herkomer's *Brewer's Drayman* (a print familiar to van Gogh). The pale ground gives full weight to the deep blue uniform, enlivened with yellow. The face is rendered with softer colours, but retains our attention through the use of small broken touches of paint. The simple green-painted table, almost superfluous, provides an additional note of wholesome simplicity.

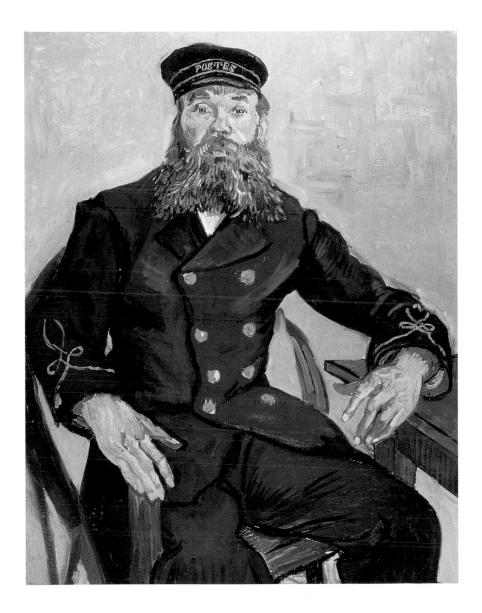

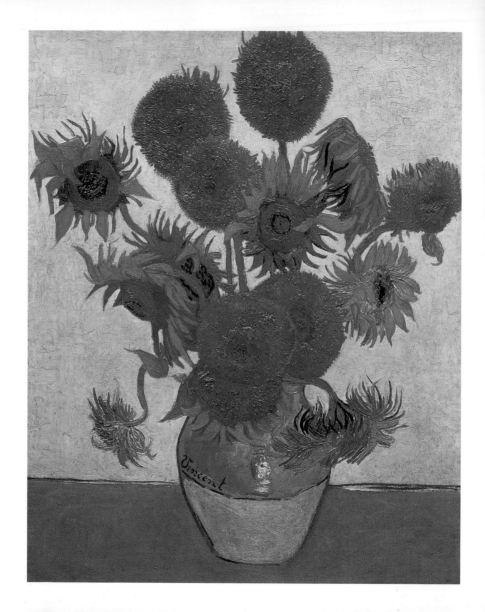

Vase of Sunflowers August 1888

93 x 73 cm

Oil on canvas

National Gallery, London

This picture is part of a series with which van Gogh decorated
the Yellow House, the house that he rented in the Square
Lamartine in Arles, in preparation for receiving visits from his
brother and, as he hoped, from Gauguin. At the time, he was
'painting', as he wrote to Theo, 'with the enthusiasm of a Marseil-
lais eating bouillabaisse'. The room was to have white walls 'with
a decoration of great yellow sunflowers … it will not be
commonplace'. In this version there is a satisfying balance
between the weight of the bunch and the stoutly rounded
earthenware vase in which they stand. The flowers are varied
as if each had a distinctive character, and within the 'Japanese'
simplicity of the almost monochrome palette, a range of yellow
tones is brought to life by a thin blue line.

The Old Peasant (Patience Escalier) August 1888

69 x 56 cm

Oil on canvas

Private Collection

This is the second and best-known portrait of Patience Escalier, a sort of 'man with a hoe', as van Gogh called him, referring to Millet's uncompromising image of rural labour. He described its colouring to Theo: 'against a background of vivid orange which, although it does not pretend to be the image of a red sunset, may nevertheless give a suggestion of one'. Already, in Paris, van Gogh had developed the practice of painting portraits without any reference to a conventional rendering of complexion, but using instead vibrant, strawlike touches, 'flaming visages', as Émile Bernard called them, keeping the face in perpetual movement like a field of wheat. The intensity of the orange background and blue smock are of course heightened by the fact of their being complementary colours. Van Gogh's fondness for graphic contour is seen in the red outline of the hat, and certain of the folds in the smock.

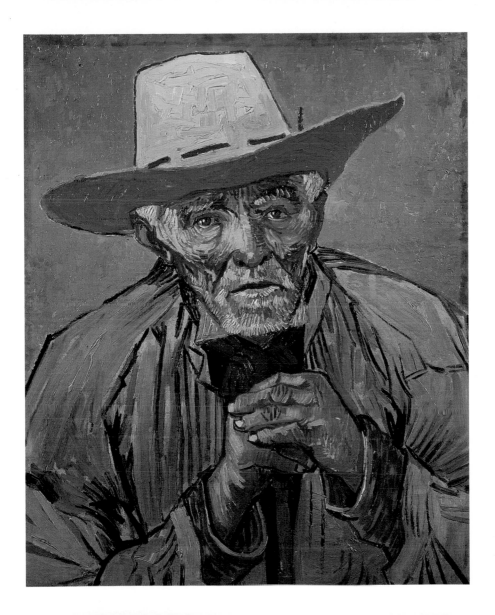

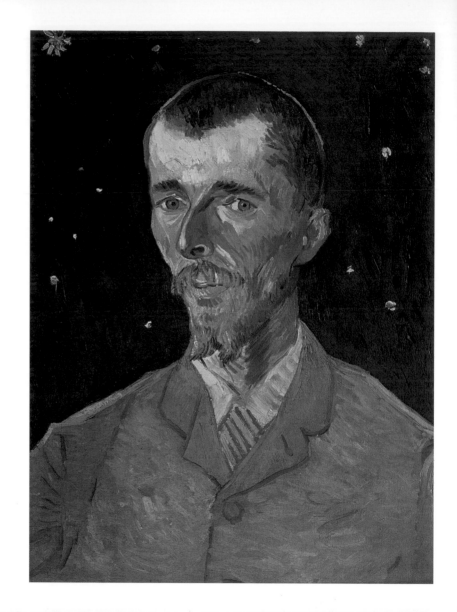

Portrait of Eugène Boch September 1888

60 x 45 cm

Oil on canvas

Musée d'Orsay, Paris

The subject of this portrait is a young Belgian painter in whom van Gogh saw a look of Dante, and who was, like himself, an admirer of Delacroix, from whom van Gogh had learned the possibilities of the expressive use of colour. It is perhaps in van Gogh's portraits that we find his own use of colour at its most 'arbitrary'. 'In a picture I want to say something comforting, as music is comforting', he wrote, 'I want to paint men and women with that something of the eternal which the halo used to symbolize ...'. And so, in this portrait, as he wrote to Theo, 'behind the head, instead of painting the ordinary walls of the mean room, I paint infinity, a plain background of the richest, intensest blue that I can contrive ...'.

Starry Night September 1888

72.5 x 92 cm

Oil on canvas

Musée d'Orsay, Paris

'Looking at the stars always makes me dream', van Gogh wrote
to Theo in the summer of 1888. This, the first of two pictures of
the night sky, is a view of the Rhône at Arles, the lights of the
town reflected in the river like an echo of the stars. The Great
Bear could not, apparently, have been visible from this viewpoint,
but van Gogh probably included it for its reassuring familiarity.
The foreground, reduced to a small wedge of land, gives that
part of the composition the look of a Japanese print, with two
mysterious figures like those in the *Memory of the Garden at Etten*
(*see page 103*). The picture has something of the atmosphere of
Symbolist poetry, as do van Gogh's own remarks: 'Why, I ask
myself, shouldn't the shiny dots of the sky be as accessible as
the black dots on the map of France? Just as we take the train to
get to Tarascon or Rouen, we take death to reach a star. One
thing undoubtedly true in this reasoning is that we *cannot* get to a
star while we are alive, any more than we can take the train when
we are dead.'

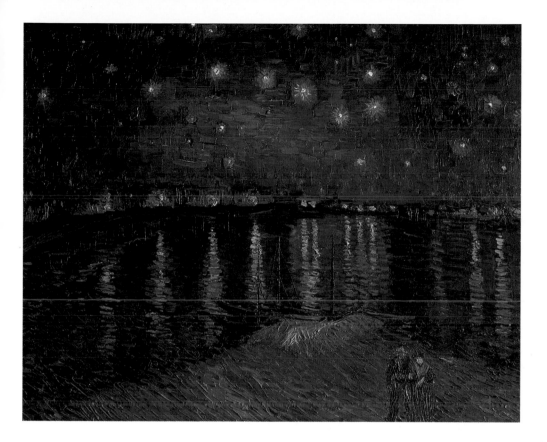

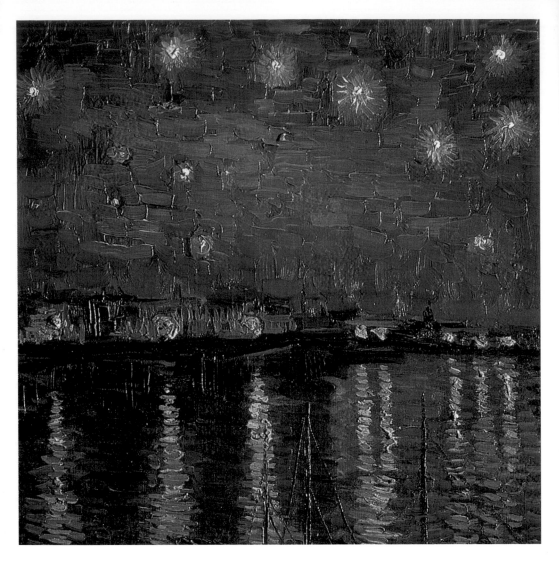

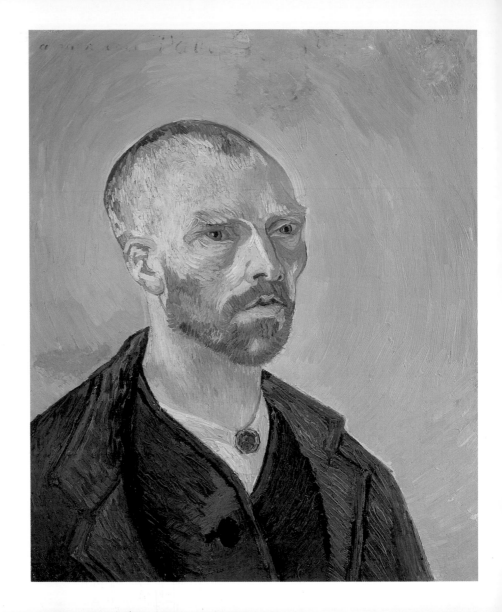

Self-portrait September 1888
62 x 52 cm
Oil on canvas
Fogg Art Museum, Harvard University,
Cambridge, Massachusetts

Van Gogh's preparations for a 'studio of the South' involved an exchange of self-portraits. He wrote to Gauguin describing the picture of himself that he would send to his friend: 'The ashen grey colour that is the result of mixing malachite green with an orange hue, on pale malachite ground, all in harmony with the reddish-brown clothes.' He was here describing the principles of combination based on complementary colours, which he derived both from his reading and from studying the work of Delacroix. Gauguin's own practice was rather different: he frequently used close rather than complementary hues. However, van Gogh continued, in a vein more likely to appeal to the mystical inclinations of his friend, 'But as I also exaggerate my personality, I have in the first place aimed at the character of a simple *bonze* [a Japanese monk] worshipping the eternal Buddha.' Once again, the notion of working with simplicity and clarity is associated with Japan, and the faint light breaking in radiance behind the head confirms van Gogh's wish to suggest that the artist's calling is in a sense sacred like that of a monk.

Public Garden with a Couple and a Blue Fir Tree

October 1888

73 x 92 cm

Oil on canvas

Private Collection

Pictures of gardens, perhaps because of their highly personal
associations, are among the subjects that seem to have held
special significance for van Gogh. This glimpse of part of the
public garden at Arles, two lovers in the shadow of a tree, is one
of a series he called *The Poet's Garden* (Petrarch was associated
with Avignon, not far away, but van Gogh also had Dante in
mind), with which van Gogh decorated the Yellow House in
eager anticipation of the community of artists it would in time
receive. The heavy impasto of the sweeping branches of the
great blue-green fir may owe something to Adolphe Monticelli
(1824–86), an artist whom van Gogh admired, and who was
also associated with the south.

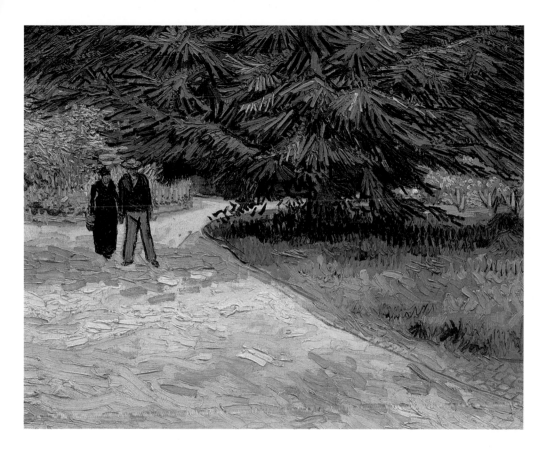

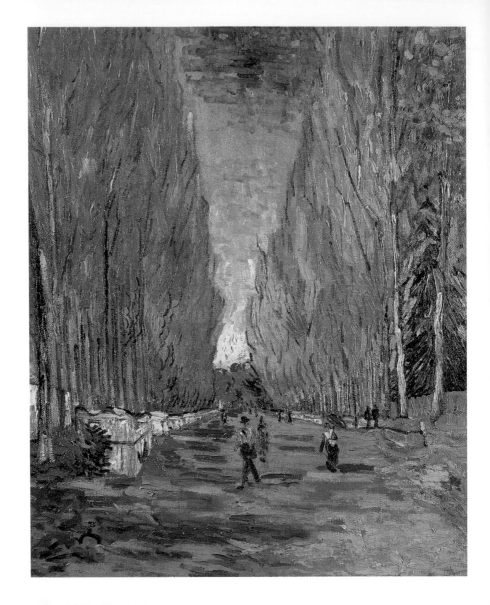

Les Alyscamps November 1888
92 x 73.5 cm
Oil on canvas
Private Collection

Van Gogh explored Arles in Gauguin's company, and made
three pictures of this late Roman cemetery, whose name
means the Elysian Fields. This view recalls a picture made long
previously, at Nuenen, of an avenue of poplars in which two
figures walk through fallen leaves, a Gothic church appearing
on the skyline. But here it includes smoking factories, and is
rendered with all the extraordinary and 'arbitrary' use of colour
that van Gogh had adopted in the interests of expression and
had heightened in response to Gauguin's own idiosyncratic
palette: greenish sky, thinly painted flame-coloured poplars
with blue trunks, a clump of yellow and scarlet trees at the
end of the vista.

Memory of the Garden at Etten November 1888

73.5 x 92.5 cm

Oil on canvas

The State Hermitage Museum, St Petersburg

It was not van Gogh's habit to paint from his imagination, but Gauguin encouraged him to allow himself more freedom. The result is an uncharacteristic and mysterious picture. As the title suggests, the painting had its origin in memory – of the vicarage gardens of his childhood and youth, and, as he wrote to his sister, of the books he read then: '… there is not the least vulgar and fatuous resemblance, yet the deliberate choice of the colour, the sombre violet with the blotch of violent citron yellow of the dahlias suggest Mother's personality to me. The figure in the Scotch plaid … against the sombre green of the cypress … further accentuated by the red parasol … gives me an impression of you like those in Dickens's novels …'. The bending figure is a quotation from his own studies in the fields at Nuenen, and thus is an early example of the reworking of old images that was to occupy him the following year. To find it combined here with an evocation of Etten suggests the extent to which the later reworkings sprang from a longing for home.

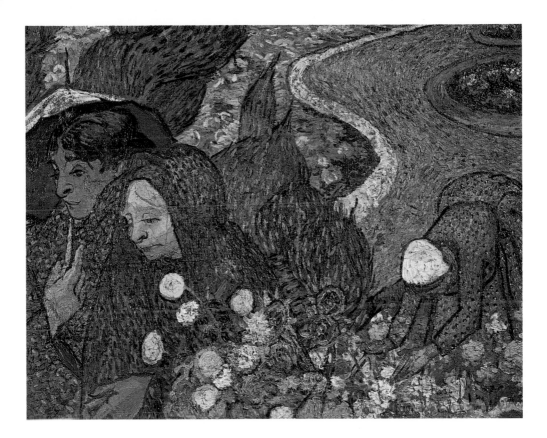

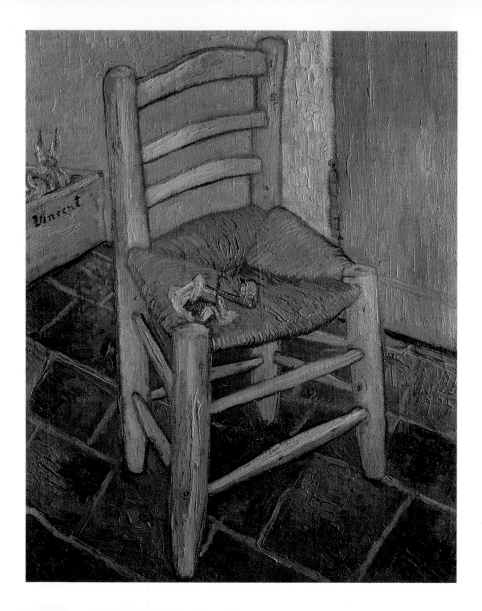

Van Gogh's Chair November 1888
93 x 73.5 cm
Oil on canvas
National Gallery, London

In 1890 van Gogh wrote to his sister, 'portraits … like furniture
one knows,… remind one of things long gone by'. Here, it is the
chair that seems to play the part of a portrait; it was intended as
a pendant to the picture entitled *Gauguin's Chair* that van Gogh
painted after Gauguin's departure from Arles. Gauguin's chair
was a more elaborate one in which Madame Roulin later sat
(*see pages 109–11*); van Gogh's has all the simplicity of his
bedroom at Arles, where it appears to belong (*see page 118*).
The tiny space in which it is enclosed, the blue line defining its
edge, and the liveliness with which it stands obliquely on the red
tiles reinforce its independent character. The picture is painted
on the coarse brown canvas that Gauguin used at Arles, clearly
visible at certain points. It accords well with the box of onions
upon which van Gogh has written his name.

Armand Roulin December 1888

65 x 54 cm

Oil on canvas

Museum Boymans van Beuningen, Rotterdam

Van Gogh's attachment to the members of the Roulin family can be assumed from the number of portraits he made of them, including the baby, and the picture that amounts almost to an icon of comfort and consolation, *La Berceuse* (*see pages 109–11*). Armand was the older of the two sons, and van Gogh made two very different portraits of him, one in a yellow coat, faintly rakish, a silhouette like a figure by Frans Hals, and this, more classical version, in which the sitter is seen in near profile, absorbed, the lavender hues of the knotted tie offering relief, without strong contrast, from the dark blue of the hat and coat and harmonizing with the sombre but resonant ground.

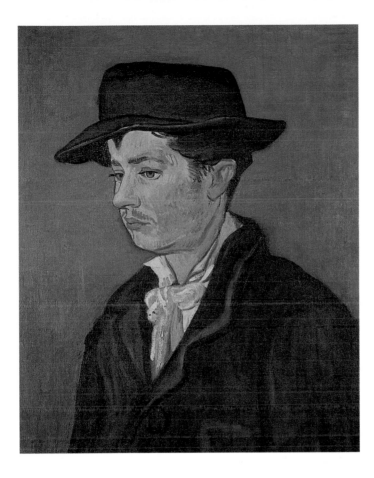

La Berceuse 1889

92.8 x 73.7 cm

Oil on canvas

Private Collection

Between his breakdown in December 1888 and January 1889, van Gogh painted five versions of this portrait of Madame Roulin. The work recalls Gauguin in various ways: the golden face, pale hair, emphatically contoured forms, and flat areas of strong colour. As we know from the letters, there is an underlying reference to a favourite book of Gauguin's, Loti's *Icelandic Fisherman*. Van Gogh wrote to Theo of wishing to paint 'a picture in such a way that sailors, who are at once children and martyrs, would feel the old sense of being rocked'. The title could suggest a piece of music, as well as the woman who rocks the cradle (indicated by the rope she is holding). To a painter friend, he concluded, 'Whether I really sang a lullaby in colours is something I leave to the critics.'

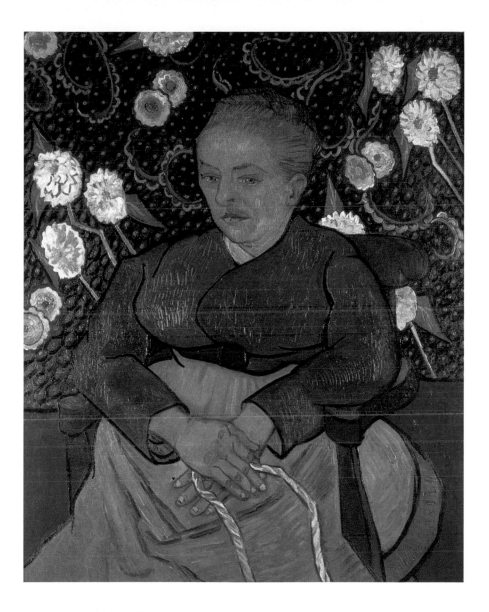

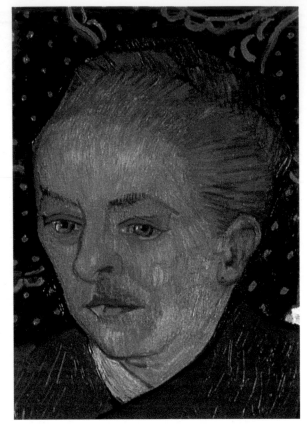

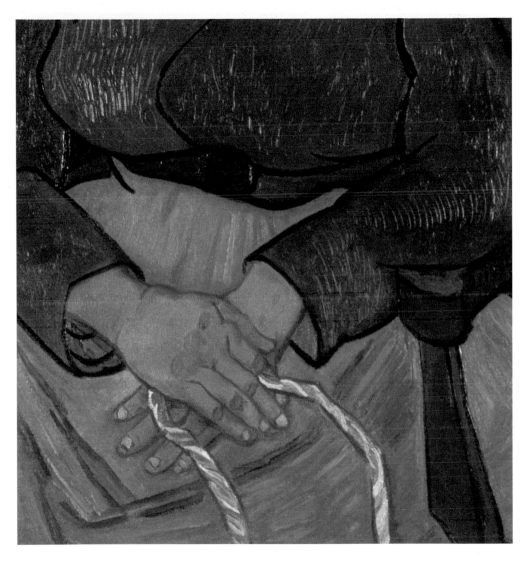

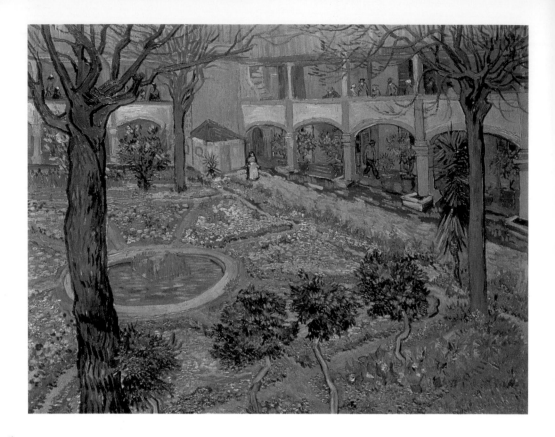

The Asylum Garden at Arles April 1889

73 x 92 cm

Oil on canvas

Oskar Reinhart Collection, Winterthur, Switzerland

From the hospital at Arles, just before his removal to the asylum
at Saint-Rémy, van Gogh wrote to his sister about two pictures
that he had recently finished: one of the interior, 'all white, lilac
white or green white. Here and there a window with a pink or
bright green curtain'; and this picture of the arcaded inner court,
'an antique garden with a pond in the middle and eight flower-
beds, forget-me-nots, Christmas roses, anemones, ranunculus,
wall-flowers, daisies, and so on. And under the gallery, orange
trees and oleander. So it is a picture quite full of flowers and
vernal green. However, three gloomy black trees pass through it
like serpents, and in the foreground four big dismal clusters of
box shrub. It is probable that people here won't see very much in
it, but nevertheless it has always been my great desire to paint
for those who do not know the artistic aspect of a picture.' The
conclusion reminds us of the missionary enthusiasm that van
Gogh brought to his work.

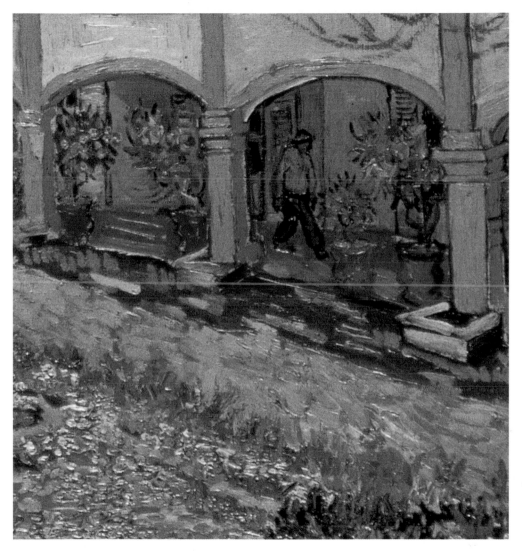

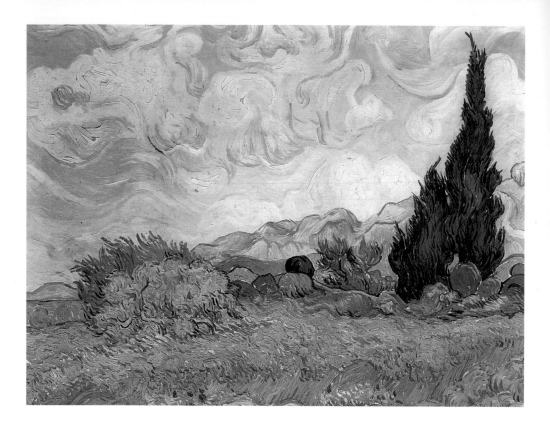

Wheatfields with Cypresses June 1889

72.5 x 91.5 cm

Oil on canvas

National Gallery, London

The use of graphically rounded forms, visible in the signature
on the *Vase of Sunflowers* (*see page 86*), and much in evidence
in the background of *La Berceuse* (*see pages 109–11*), becomes
a unifying force in many of the works painted at Saint-Rémy,
surviving in softened and more fluent manner at Auvers-sur-Oise.
The flaming form of the cypress, and the grey-green olive trees,
make it clear that we are in Provence, but the 'arbitrary' colour
associated with the wheatfields of the previous year has given
way to a more naturalistic palette, and the cloudy skies and
stirring wind suggest that van Gogh was thinking again of the
north, as he frequently did at this period.

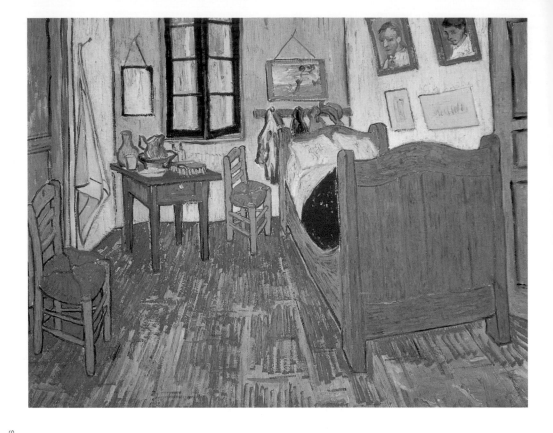

Van Gogh's Bedroom at Arles September 1889

56.5 x 74 cm

Oil on canvas

Musée d'Orsay, Paris

Van Gogh made his first picture of this room in October 1888.
The painting was damaged while he was in hospital, so he made
a second for Theo. This version, however, is yet another copy,
made for his mother and sisters, and was painted almost a year
later in the asylum at Saint-Rémy, when he was making a series
of copies after works that held particular significance for him by
Millet, Delacroix, and Rembrandt, and of some of his own
pictures. There is a deliberate simplicity in this version that
exceeds that of the other two; the curious angles where the
walls meet the ceiling have been eliminated; the contrasts of
colour are more emphatic: red and green, blue and orange,
black and white, and, in the landscape next to the window, the
gentle notes of pink and green he used towards the end of his
stay at Saint-Rémy. To his sister he wrote, 'I wanted to achieve
an effect of simplicity of the sort one finds described in Felix Holt
… Doing a simple thing with bright colours is not at all easy,
and I for my part think that it is perhaps useful to show that it is
possible to be simple by using something other than grey, white,
black, or brown.'

Noonday 1889–90

73 x 91 cm

Oil on canvas

Musée d'Orsay, Paris

Van Gogh took his collection of prints with him to the asylum at Saint-Rémy. One of them, a *Pietà* after Delacroix, fell into some paint, and was spoilt. It was while making a painted copy of the other artist's picture that he saw the interest offered by such an exercise, which he was to compare to musical interpretation, and thereafter made a total of 34 such paintings, of which Millet's compositions form an important part. They include two series, the *Labours of the Fields* (*Travaux des champs*) and the *Times of Day*, to which this one belongs. As a beginner, van Gogh had previously made drawings after both series. Millet's *Times of Day* images were originally in crayon, and the character of the medium was retained in the print. Van Gogh has imitated in oil the strawlike touches and allowed them to form series of patterns. Many, though not all, of these painted copies are harmonies in blue and yellow.

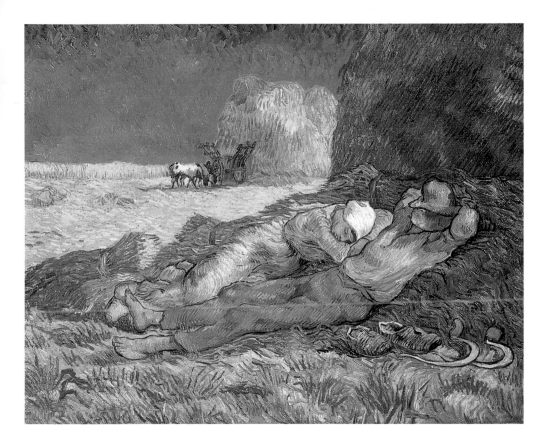

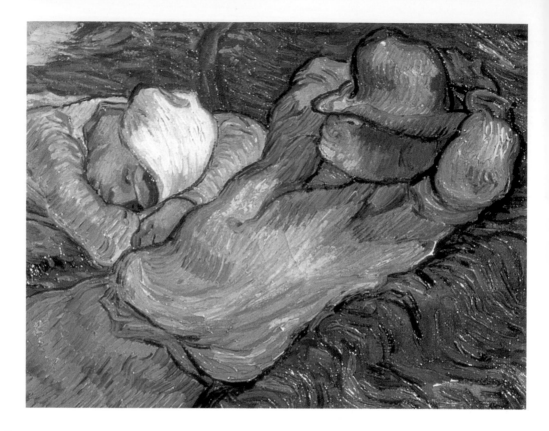

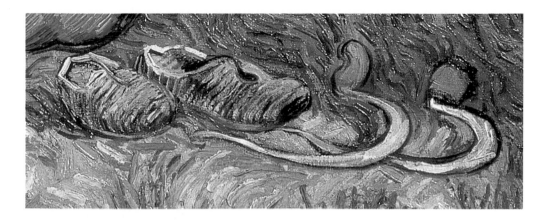

Self-portrait September 1889

65 x 54 cm

Oil on canvas

Musée d'Orsay, Paris

In this portrait, made at Saint-Rémy, van Gogh uses a palette similar to that used for the copies he was working on at the same time. It gives the curious effect of translating himself into a contained image, the curling forms describing his clothes flowing at times into the swirling background, which looks like the waves of the sea, or perhaps the wind in a field of wheat.

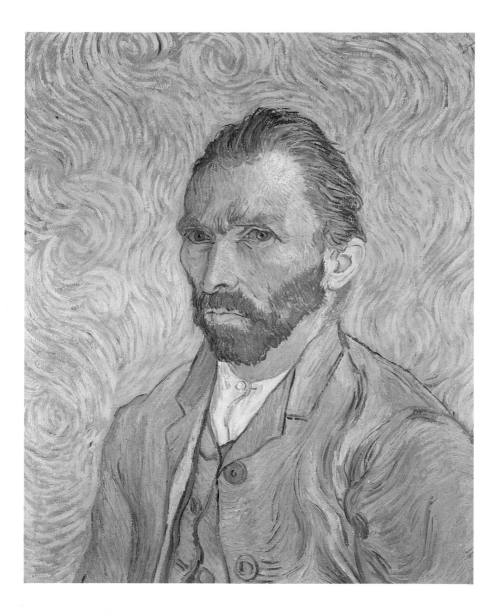

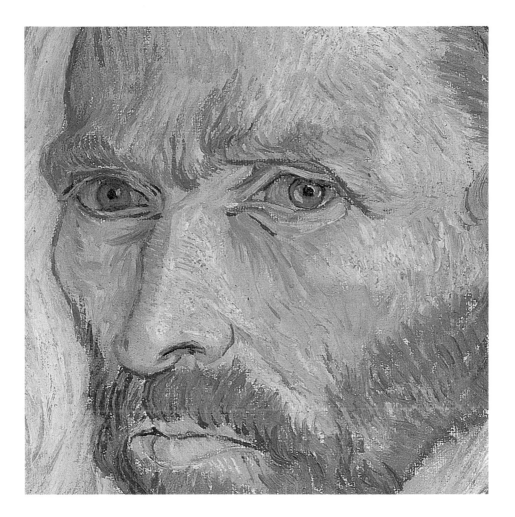

L'Arlésienne: Madame Ginoux (after Gauguin) 1889

65 x 54 cm

Oil on canvas

Museu de Arte de São Paulo, 'Assis Châteaubriand',

São Paolo, Brazil

This portrait of Madame Ginoux, who was the wife of a café owner in Arles, is based on a drawing by Gauguin, left behind at Arles. Thus, like several other paintings, it indicates van Gogh's admiration for his friend. The books on the table are not, as so often in his pictures, modern French novels, but translations of Dickens's _Christmas Stories_, and _Uncle Tom's Cabin_, about the second of which he had written to his sister a year earlier: he had 'reread it with extreme attention, for the very reason that it was a book written by a woman, written, as she tells us, while she was making soup for the children'. As for the Dickens stories, familiar from childhood, he reread them, too, in the hospital at Arles. The account comes from the letter in which he mentions the 'lilac white', of the hospital walls, and the 'pink or green' of the curtains. The use of these colours here may suggest a state of convalescence appropriate to the sitter as well as to himself, for Madame Ginoux, too, had been ill.

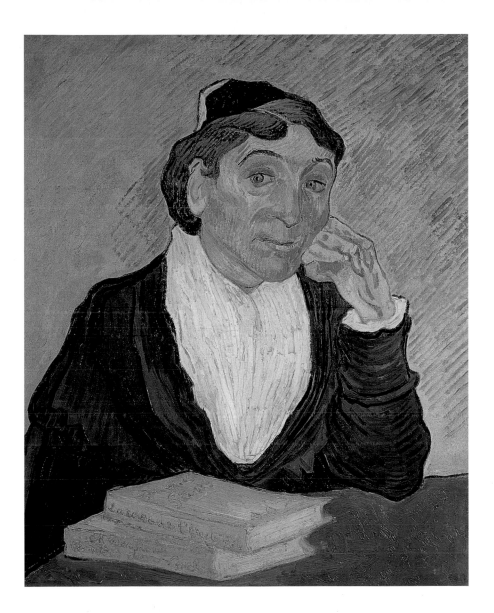

Return to the North

PAINTINGS OF 1890

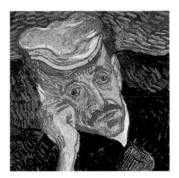

Vase of Roses May 1890

93 x 72 cm

Oil on canvas

Private Collection

The pink and green tonality of this picture, like the portrait
of Madame Ginoux (*see page 129*) suggests a settled mood
different from the visionary note of the sunflower series of two
years earlier. Van Gogh wrote to Theo that: 'my head is
absolutely calm for work and the brushstrokes come to me and
follow each other logically'. It was painted in his last days at the
asylum of Saint-Rémy, at the time when his doctor pronounced
him able to leave. He described those days to his sister: 'I still
worked as if in a frenzy. Great bunches of flowers, violet irises,
big bouquets of roses, landscapes.' The pigments of this picture
have apparently faded slightly; the original blend of pink and
white tones in the flowers would have been in closer harmony
with the table-top. The fluent dancing lines recur in the paintings
from Auvers.

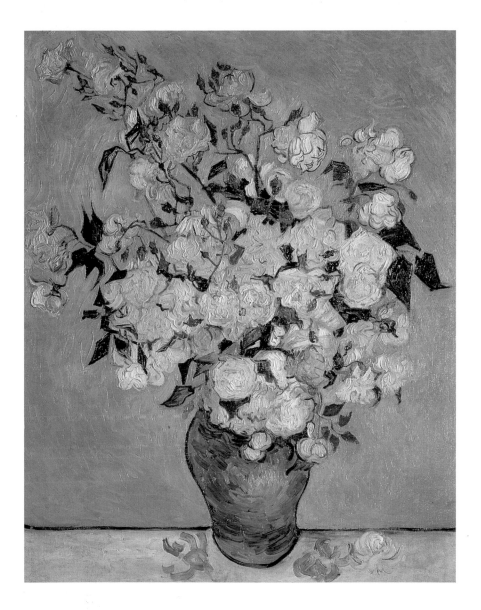

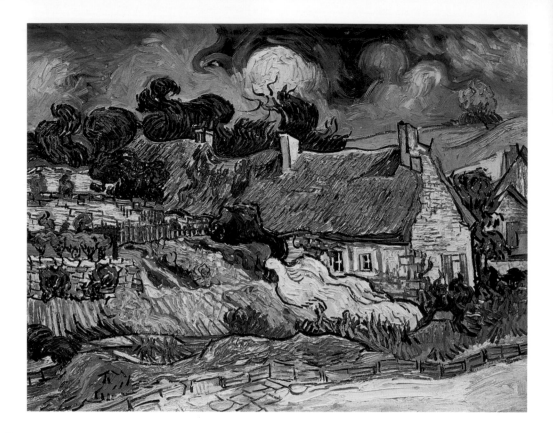

Thatched Cottages at Cordeville, Auvers-sur-Oise

May 1890

72 x 91 cm

Oil on canvas

Musée d'Orsay, Paris

Van Gogh was always susceptible to the charm of mossy thatch,
and to the friendly lights of cottage windows glimpsed from afar:
these huddled houses, with gently flowing outline, part of a series
begun shortly after his arrival at Auvers, suggest the feelings of
dulce domum with which van Gogh wished to endow the little
town, his 'North' regained, just as the south had been Japan.

Church at Auvers-sur-Oise June 1890

94 x 74 cm

Oil on canvas

Musée d'Orsay, Paris

Van Gogh described this picture to his sister as 'an effect … in which the building appears to be violet-hued against a sky of simple deep blue colour, pure cobalt; the stained-glass windows appear as ultramarine blotches, the roof is violet and partly orange'. Revealingly, he goes on to say: 'It is nearly the same thing as the studies I did in Nuenen of the old tower and the cemetery.' The ruined tower that he mentions had for him peculiar potency as an image: 'I wanted to express what a simple thing death and burial is, just as simple as the falling of an autumn leaf … the life and death of the peasants remain forever the same, budding and withering regularly, like the grass and the flowers growing there in the churchyard.' Reworking old images in 'more expressive, more sumptuous colour', as he wrote, might be seen as a development of his practice at Saint-Rémy of 'transposing' prints into paintings.

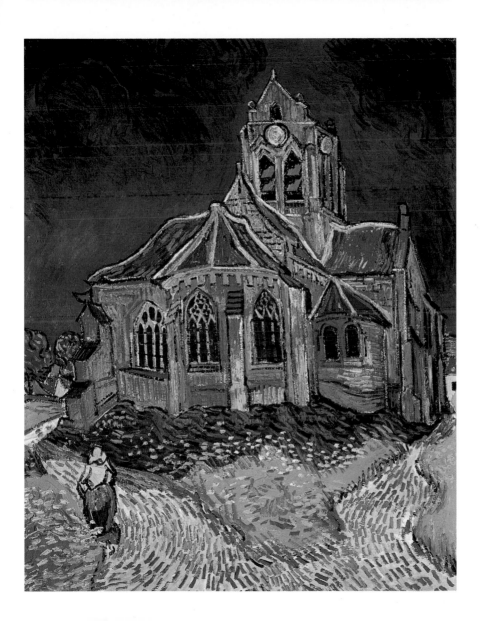

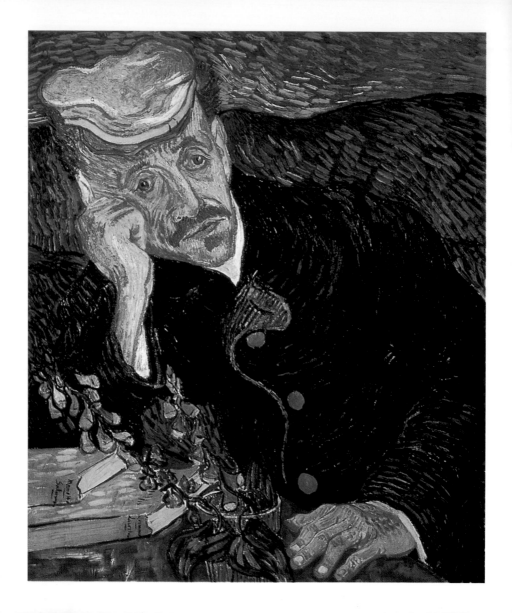

Dr Gachet June 1890
66 x 57 cm
Oil on canvas
Private Collection

For van Gogh, as for Baudelaire, melancholy was the hallmark
of the modern condition. To express it was therefore part of his
work as an artist. Dr Paul Gachet, a figure in whom van Gogh
saw many resemblances to himself, leans his head on his
hand in the traditional pose of Melancholy: two novels by the
Goncourts, *Manette Salon* and *Germinie Lacerteux*, attest to the
modernity of this current version of the mood. The foxglove
flower, digitalis, is, like a saint's attribute, the sign of Gachet's
medical calling. To his sister, van Gogh wrote: 'What impassions
me most – much, much more than all the rest of my *métier* – is
the portrait … I should like to paint portraits which would appear
after a century to the people living then as apparitions.'

Wheatfields under Troubled Skies July 1890

50.5 x 100.5 cm

Oil on canvas

Rijksmuseum Vincent van Gogh, Amsterdam

Much has been written about this picture, which is
sometimes described as if it were a testament of despair.
The depth of colour, almost a mockery of the early happy
harvest scenes of 1888, the perspectives which rush
alarmingly towards the viewer, the dark sky, lowering
clouds, black crows, and, not least, van Gogh's own
words to Theo – 'I did not need to go out of my way to
express sadness and extreme loneliness' – suggest
that it *is* a tragic image. However, the pictures from this
last period, particularly the landscapes and the cottage
series, but also the portrait of Gachet (*see page 138*),
show that van Gogh was succeeding in finding a new
and congenial imagery for reworking the themes of the
relationship between human existence and nature that
had always preoccupied him. The letter quoted above
continues: 'these canvases will tell you what I cannot
say in words, the health and the restorative forces that
I see in the country'.

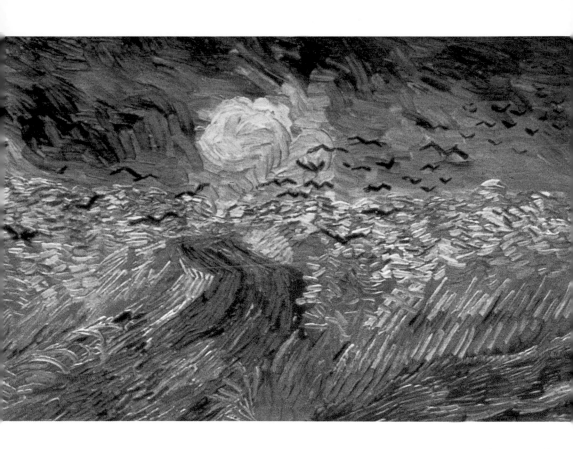

Return to the North

Chronology

1853	Vincent Willem van Gogh born at Zundert in Brabant, eldest surviving child of Theodorus van Gogh and Anna Carbentus
1857	Birth of Theodorus (Theo), Vincent's brother
1869	Joins the Dutch branch of the firm of Goupil and Co in The Hague
1873	Transferred to the London branch of Goupil
1875	Sent to work in the main Goupil gallery in Paris
1876	March: leaves Goupil and returns briefly to London, where he works as an unpaid assistant in a school; December: returns to his family at Etten in Holland
1877	Works in a Dordrecht bookshop; May: begins preparatory study for a theology degree in Amsterdam
1878	After three months of study at a missionary school in Brussels, works as a lay preacher in the mining area of the Borinage in Belgium
1880	Begins to practice drawing, making copies after Millet

1881	After a short stay in Brussels, returns to live with his parents at Etten; moves in December to The Hague, where the painter Anton Mauve, his cousin by marriage, helps him to settle
1882	Lives with Clasina Hoornik (Sien); makes many drawings from life; reads Alfred Sensier's biography of Millet
1883	Leaves Sien in September, and goes to live in the rural region of Drenthe in north-east Holland; draws and paints the work of the fields
1884	Returns to his family, now living at Nuenen; paints weavers and studies of rural workers
1885	Death of his father; completes *The Potato Eaters*; leaves for Antwerp where he enrols at the Art Academy
1886	Joins Theo in Paris at the end of February; enrols at Cormon's studio, and meets Toulouse-Lautrec, Bernard, and Gauguin, and becomes familiar with Impressionism
1887	Paints at Asnières with Bernard; takes part in a group exhibition at Le Tambourin café

1888 February: moves to Arles; June: visits the sea at Saintes-Maries-de-la-Mer; October: Gauguin arrives; December: van Gogh suffers breakdown; goes into hospital at Arles; Gauguin returns to Paris with Theo

1889 Enters, at his own request, the asylum of Saint-Paul-de-Mausole at Saint-Rémy, and paints in his room, in the garden, and from his window; makes copies from prints after Millet and other artists, as well as some of his own early subjects

1890 Albert Aurier publishes a glowing account of his work in the *Mercure de France*; Theo chooses ten works by his brother to exhibit at the salon of the Société des artistes indépendants in Paris; May–July: at Pissarro's suggestion, van Gogh goes to stay at Auvers-sur-Oise, where Dr Paul Gachet, friend of several Impressionist painters, can look after him; July 27: attempts suicide; July 29: dies of his wounds; Theo dies six months later

Credits

Source of all quotations from letters: *The Complete Letters of Vincent Van Gogh*, 3 vols, London, Thames and Hudson 1958.

Picture Credits

Index